S0-AAD-852

The POWER of SUPER 8 FILM

Insider Secrets Every Filmmaker Should Know

by Phil Vigeant

Published by Pro8mm

Copyright (c) 2010 Phil Vigeant

All rights reserved. No part of this book may be reproduced or transmitted in any form or by any means, electronic or mechanical, including photocopying, recording, or by any information storage and retrieval system without written permission of the publisher, except for the inclusion of brief quotations in a review.

Printed in the United States of America

Vigeant, Phil
 THE POWER OF SUPER 8 FILM: Insider Secrets Every Filmmaker Should Know/ by Phil Vigeant

 ISBN: 978-0-615-34552-9

Cover Design by Joe Potter
Layout by Dawn Teagarden
Edited by Merle Bertrand
Bio Photo by Sean Baello
Contributing Photographers/Photographs from
 Rei Sutton, Mauro Pagualonga, Michelle Heighway, Giles Perkins,
 Carleton Torpin, Sean Blosl, Megan Hill, David Dibble, Jeremy Smith

Special Thanks to David Williams

Warning – Disclaimer
The purpose of this book is to educate and entertain. The author or publisher does not guarantee that anyone following the techniques, suggestions, tips, ideas, or strategies will become successful. The author and publisher shall have neither liability or responsibility to anyone with respect to loss or damage caused, or alleged to be caused, directly or indirectly by the information contained in this book.

FOR

My wife Rhonda
The Power House who inspires me;

My daughters Jaclyn, Brittany and Stefani
The empowered women who support and encourage me;

The Hollywood Power Players
Who believed in me, and;

The Millennium Generation
To whom the staying power of Super 8 lies.

WHAT OTHERS ARE SAYING

"With the renaissance of Super 8 and its establishment as a desirable imaging medium, the time is right for a contemporary guide to this unique format. The Power of Super 8 Film couples Phil's encyclopedic knowledge with recent technical innovations to provide an essential guide for newcomers and seasoned users alike."

-Giles Perkins, Editor, onsuper8.org, Super 8 Filmmaker

"Super 8 continues to have a great following of creative people and a steady flow of new "converts". Phil's commitment to support this at the highest quality, with investment and enthusiasm, is impressive. He just transferred some of my old Super 8 films to Blu-Ray. They look superb."

-Peter Boyce, Regional Business General Manager, Eastman Kodak Company

"A common anecdote among Cinematographers is how the Super 8 films they shot during their youth put them on their career paths. Today they are using Super 8 film to shoot flashbacks because small format film is an organic medium, which evokes emotional responses. Film is also the only proven archival medium. Phil Vigeant's Book The Power of Super 8 Film belongs in every film school library."

-Bob Fisher, Cine Journalist, President, CCS Public Relations

"Shooting with super 8 gives you the feeling you can fly. You are so unshackled, and free. Phil and the entire crew at Pro8mm makes you feel as though you have a partner in film. They want you to succeed as badly as you do. They've got the tools and know-how to make your dreams fill the screen."

-Kurt Markus, Award Winning photographer, Independent Filmmaker for Jewel and John Mellencamp

"With the push to make television and video look more and more true to life, people forget that film allows us to see the world literally in a different light. Shooting with The Pro8mm Max 8 camera provided stunning imagery, and the 16x9 framing gave us the flexibility to seamlessly incorporate the footage into our project. The full HD scans showed that the 8mm frame can hold so much beautiful visual information. The super 8 format enhanced the overall mood of our project. Indie filmmakers should all take the plunge and shoot on super 8 film."

-Bryan Roberts and Nolan Ball, Indie Filmmakers

"Phil and the team at Pro8mm has kept the super 8 medium alive through timely innovations, including state of the art HD digital scanning, 16 x 9 film gate modifications, crystal sync and negative film. He has the gift of adapting the Pro8mm format to meet the most demanding uses in today's competitive world of cinema and television production. Pro8mm has been my medium of choice for acquiring motion picture imagery in the production of music videos, TV shows, documentaries, commercials, and most recently as an effective low cost teaching tool for college filmmakers. He is, in my opinion, the King of Super 8."

-Daniel Jacobo, M.F.A. UCLA Film School, Professor, Chaffey College

TABLE OF CONTENTS

The Power of
Super 8 Film

Steven Spielberg. George Lucas. Oliver Stone. Joel Schumacher. John Toll. James Chressanthis. Sam Raimi. Steven Soderbergh. Robert Richardson. Robert Elswit. Edward Lachman. Jim Jarmusch. Stephen St. John. Ben Affleck. Neil Young. Jason Lee. Nike. Madonna. Beyonce. The list could fill this book. They are accomplished film industry insiders that have something in common: they have all used 8mm film. They've made it. Do they know something that you might not? Yes. They know about the Power of Super 8 Film. This book will enlighten you as to why the pros use it, love it and keep it a secret.

These are the icons that aspiring filmmakers look to in order to find their inspiration. What was their path? Who were their mentors? How did they make it? Just like you, they began somewhere, emerging from the unknown to become someone who represents a body of filmmaking so well known, that just saying their name or the title of one of their films conjure up images of moviemaking triumph!

Introduction

Many emerging filmmakers spend a fortune on equipment, expensive university film programs, private filmmaking boot camps, or over-priced post-production that often renders mediocre quality, and still feel as if something is missing. They look at their progress as marginal compared to their financial investment, time commitment and ability to work the craft.

That is the purpose of this book. You will get the inside skinny of my expertise from running a company that has worked with these industry insiders for 30 years. I believe that necessity is the mother if invention. *The Power of Super 8 Film* will show you why I invented products that changed the way filmmakers and the entertainment industry have used Super 8 film, emerging from a format used to shoot home movies in the 1950s-1970s to a professional production medium. Pro8mm workflows have been used in hundreds of commercials for your favorite brands, dozens of 35mm theatrical releases, award winning music videos and television shows.

The Power of Super 8 Film will guide you through the steps you should take to immediately give you the experience of shooting film on film, the way all the greats did. I'm going to tell you how to get a huge bang for your filmmaking buck by using an inexpensive Super 8 camera, a 50' cartridge of film, chemistry and the very best in digital scanning.

It takes understanding and connection to become a filmmaker. Today more than ever, understanding the process of film as the roots of the film industry is critical to moving forward. You must be willing to learn from the past to create a successful future.

Whether you're new to filmmaking, have been around for awhile shooting on the Red, a wedding videographer who has thought about shooting some Super 8 at your next gig, a film school graduate who never actually shot anything on film, an Indie Filmmaker curious about the process, or someone who has taken the journey before and needs an update, this book is for you.

The Power Play

It always amazes me how far people who work in video or digital will go to try and make their projects look like film. There are software programs that purport to achieve this so-called "Film Look," yet all you ever get out of these is a shoddy imitation of the way film looks. What you really need if you want a production to look like film is film. However, many applications do not need to bear the cost of a full-on film production. The power of Super 8mm film comes from its ability to create the pleasing aesthetics of film at a fraction of the cost of a traditional film production.

Motion picture film has many different looks depending on the type of film stock you use and the way you work with it. Shooting with available light or lighting a scene will each create a unique film look. Shooting in color or black and white will obviously affect the look. How the camera work is done will affect the look.

What will have surprisingly little effect on the project's look, if that project is destined for the small screen, is the

size of the film you shoot on. When you project Super 8 film that's been shot as part of a theatrical movie, it looks different than the 35mm film because the effects of blowing up such a physically small square of film material are dramatic in terms of both the film's grain and its resolution. But if you take Super 8 film and compress it for display on your iPhone or on the Internet, it is very difficult to tell the difference between Super 8 film and material that was shot on other film gauges. This is because the Super 8 is made from 35mm film just in a smaller size. Even if you could discern a difference, it would still be small compared to the difference in the look between material shot on film and in digital.

With that in mind, you can see why Super 8 film has become very popular with people who want the look of film without having the ability to afford full-scale film production. A good example of this is the Wedding Market.

Why do brides want to see themselves on film rather than in digital? A woman on her wedding day wants to be the movie star in her own motion picture and, as there is an emotional association with the quality and nostalgia of film, the videographer that can offer them this will get the job. Since most movies were shot on film, the simplest way to give your bride the look that she is in a movie is to expose her on film.

While it is hard to put a price tag on what that film look gives you, it is obvious to me, given the amount of

attention it gets, that value must be substantial. Obviously you can't afford a full-on film production and the bride might never look like Cameron Diaz in *My Best Friend's Wedding*, but you will come closer to making her look like a movie star by shooting Super 8 film than if you shoot in digital.

Nike "Revolution"

In 1985, the idea of a Professional Super 8mm film format had not occurred to many people, including me. Until this point, Super 8 use was usually relegated to film schools and film students, although there was also a growing market of independent filmmakers who used Super 8 film in their projects. The Music Video was just beginning to emerge and, although there were little pieces of Super 8 in some early music videos, it was not significant. At that time, the notion of using Super 8 film in a professional project, let alone a national commercial, was unheard of.

I had a customer, Peter Keagan, who had shot a few projects in New York City where he used some inserts shot in black & white Super 8. He included a few Super 8 shots in the video "Higher Love" by Steve Winwood, which led to his making a commercial for Barney's Clothing. Then came the big offer to direct a commercial spot for Nike.

The Nike people were very clear with him that they

wanted a commercial shot in his style and that he was to make the commercial without hiring a professional crew.

His Nike "Revolution" spot was embroiled in controversy over the use of music by The Beatles. In addition, it was the first black & white commercial seen on television in many years. Many of the critics credit this commercial with re-establishing black and white as a commercial aesthetic.

Nike "Revolution" was shot entirely on Super 8 film.

This one commercial "revolutionized" many people's ideas about Super 8 film. No longer was it just for shooting home movies or for student use, but professionals, too, could use it to create commercial projects. Today, we take for granted the idea that filmmakers use Super 8 film in commercial jobs, but before Keagan's "Revolution" spot, no one had ever achieved so much impact with such a small piece of film.

The power this project generated in the market was a bit of a revolution for us as well. We began to look at our little film with much greater potential and started dreaming bigger about the future of Super 8 in professional applications.

It didn't take long for the enormously successful Nike spot to catch the attention of other artists. As I mentioned, the Music Video was just emerging as a new form of visual product. (For years I tried to remind people that all music videos were shot on film, but the name stuck so well it was hard to argue with people. It's kind of like how

people use the terms "film" or "filming" today, regardless of whether the artist is actually using film at all.)

Our first major music video project was produced for a young cheerleader and choreographer who had just recorded her first songs. Directed by David Fincher, (Seven, Fight Club, The Curious Case of Benjamin Button)Paula Abdul's video for the song "Straight Up" was shot entirely on Super 8 film. Like the Nike spot, it was done in black & white and also like the Nike spot, it made a huge impact on the market for Super 8 film. Her success with this Super 8 video started gaining traction with other musicians. Mariah Carey's "All I Want for Christmas Is You" became the first music video to be shot completely in color Super 8 film. Madonna produced her "Erotica" video completely in Super 8 film. Neil Young produced his documentary *Year of the Horse* almost entirely in Super 8. Videos for both of the Depeche Mode albums *Strange* and *Strange 2* were done in Super 8. These are just the projects that were completely shot in Super 8; the majority of the time, Super 8 was used in conjunction with other mediums. The list of these projects is enormous.

One other advantage of Super 8 film has been its ability to teach filmmakers the skills of visual storytelling using film. Without the availability of this inexpensive way of using moving images, how could people learn the craft of filmmaking with actual film?

Over my career, I have been given the opportunity to scan to Digital the first films made by some of the most famous people in film today. Even though I am generally bound by contract not to disclose anything about these films, I can tell you that no one is born with the fully developed gift of a filmmaker. Filmmaking is something you learn how to do through experience. I'm not sure why some individuals seemed to plateau while others grew, but we are all the beneficiaries of the fact that they did.

An example: I once had the opportunity to transfer the entire Super 8 collection of Spider-Man director Sam Raimi, and his closest early film collaborators Scott Spiegel, Robert Tapert, and Bruce Campbell. I transferred every Super 8 film they made in chronological order, up to their first commercial success, The *Evil Dead*.

There were a lot of films, if memory serves me, about 30. I did the transfer over three days, their entire pre-successful career of over 10 years encapsulated into those three days. For the first time, I could see the making of a filmmaker through the progression shown by these films. The most striking thing was that they didn't start out as great talents.

In fact, since I have subsequently transferred the films of many now-famous directors, I now realize that no one starts out great. If you put the first films of the greatest filmmakers of our time next to the early work of your average ambitious beginner, no one could tell the difference. But as each film progressed, you could see the

understanding and application of the film language unfold. By Raimi's last Super 8 film, *Within the Woods*, probably the best Super 8 film I have ever seen, an amazing filmmaker had emerged.

I had the opportunity to work with Sam Raimi again on the 35mm film, *For Love of the Game,* starring Kevin Costner, when they used Super 8 Ekatachrome for some flashback scenes.

You might argue that today with digital technology, the next generation of great filmmakers might never even need to use film. I think that their predecessors were learning not only storytelling, but also the film medium itself. 8mm film was the closest thing they could afford that allowed them to imitate the artists they admired.

If you are a filmmaker today who admires the work of Steven Spielberg or Michael Bay, you may still want to learn their art and understand the methodology of film. If you are more of a George Lucas or Robert Rodriguez fan, well then it might be digital for you all the way. I don't think the verdict on Digital vs. Film is now or ever will be out. It will be up to the artist to decide what their preferred production method is to be.

In the end, it will come down to what it always does in filmmaking: using whichever medium is the best and most cost-effective way of delivering the most powerful image possible. The modern filmmaker will have to understand both to be successful.

The
POWER
of
SUPER 8
FILM

Insider Secrets Every Filmmaker

Should Know

Power Tools - Finding a Super 8 Camera

Putting your hands on a Super 8 film camera should not be that difficult to do. In the 1960s and '70s, millions, maybe even *hundreds* of millions of cameras were sold. I once read that in that era, 1 in 3 households in the U.S. had a Super 8 film camera. In addition, most things were made of metal back in those days. By today's standards, they were way over-designed to last. The manufacturers began to change to plastic in the mid 1970's so older Super 8 film cameras are often some of the best. It is not that unusual to find a 30-year-old working Super 8 film camera.

The easiest place to go shopping is in the closet of anyone who was a parent back in that generation. If that doesn't turn up a usable camera, go to a few yard sales. Bring along a set of six AA batteries and a cartridge of film so you can check the camera's basic functions. If you're from

the Internet generation, do an eBay search for "Super 8 cameras" and you will likely find no less than 150 cameras listed for sale at any given time. (Don't forget to spell it "Super 8" Camera, not "Super8" Camera.)

The best camera is any one that works and a camera needs three basic functions to be working: The camera must expose the film correctly, transport the film and keep it in focus. The only other two functions I find very useful are the ability to shoot at 24 frames per second (fps) in addition to the standard speed of 18fps, and the ability to set the exposure both manually as well as automatically. Older cameras usually had a manual exposure setting whereas many of the plastic ones from the '70s did not.

If you can, physically inspect a camera before you purchase it so that you can at least partially check these basic functions.

Whether it will transport the film is easy to check. First, put a set of batteries — usually double A — in the camera. Next, mark the film in the cartridge you brought with you so you can tell if the film has moved. I do this by making a slight scratch with my fingernail. Insert the film cartridge in the camera, and pull the trigger. (There might be an on/off switch you'll need to flip.) If the scratch mark you made is gone, the film transport is working.

Looking through the camera can tell you something about focus and the exposure system but you can't prove

either of these is working properly unless you actually shoot some film. Super 8 cameras with lens focus problems are rare because the lens was built into the camera in most models.

Exposure problems are more common, however. Watch out for a camera that has been dropped or received water damage. Look for major dents and/or rust on the camera.

Although you obviously want to make sure that the camera you acquire is working, try to get a guarantee that you can return it if it is not. While you can find cameras very cheaply, fixing them is not cheap. This is just the law of supply and demand at work. There are millions of cameras available and only a small population of people who want to use them, so prices are cheap. You should be able to buy a good working Super 8 camera for under $100.

Camera technicians, on the other hand, are very rare and restoring old mechanical devices like cameras is time consuming, so the price for that is expensive.

If you're not the kind of person who shops for used equipment or if you have the money, you can buy a camera from a camera seller. If you go this route, remember that you are purchasing the guaranty that the camera works and will continue working more than purchasing the camera itself. Regardless of how clean a camera looks, it is about how well it works and how much support the seller provides for it. Can they fix the camera

or will they replace it if it doesn't work? Can they provide you with support in terms of how best to use it? Do they have upgrades and accessories available for the camera so you can go further with it in the future?

Because there are over 1,000 different Super 8 camera models on the market, we realized it would be impossible to try to just fix cameras. So, about 15 years ago, we began a program to rebuild select Super 8 cameras.

In order to rebuild a camera, we first had to purchase a significant supply of that given model for parts. We then invested a lot of time in understanding that particular camera completely, evaluating all its strengths and weaknesses and making improvements where possible.

We called our first camera the Classic. It is a restored Beaulieu 4000 series camera with some very fine improvements. We redesigned the power system so the camera would have a long-running, more reliable power source. We adjusted the take-up so the camera would perform better with color negative Super 8 film. We removed the 85-filter system to give it better optical performance. We designed a Crystal Sync control for shooting sync sound at either 24 or 25fps. We offered the Max 8 modification for filming in widescreen for Super 8 HD. It is, for lack of a better phrase, the Classic Motion Picture Camera.

It has taken a lot to rebuild this camera but we feel that it can be rebuilt indefinitely. Obviously all this work does

not come cheaply, however. An unmodified Beaulieu 4008 can be purchased on eBay for around $250. We sell our souped-up Classic for 10 times that.

In 2006, we tried again with the Canon 814AZ which we call the Pro814. This is a great camera that includes all the basic functions such as 24fps and manual exposure capabilities. Since we can restore this camera with a lot less work, it can be done at a less expensive price. The Pro814 rebuild takes 14 hours on average provided we start with a good camera. Some of the cameras we purchase from eBay are so far gone that we just add them to the parts pile. We have a wide gate modification for the Pro814 but not a full Max 8 mod.

Recently, we began a program with the Canon 1014XLS we call the Max1014. The Canon 1014 has long been a workhorse for the Super 8 industry. With improvements like the Max 8 modification and the capacity to service this machine, it will continue into the future. 2010 brings the release of a crystal sync version, the Max1014XTL, complete with a special new sync module designed to work with HD digital cameras.

Whether you find a gem at a yard sale or you acquire the best that money can buy in the rebuilt market, it is what you do with it that counts. Aside from all the features, you have to find a camera that fits your personality and filmmaking style. Some filmmakers like big lenses and feature-laden machines; others can use very simple tools to create empowering images.

If you're thinking about one of the more expensive rebuilt cameras, you might want to rent it for a day first to make sure it suits you. You can often work out a deal that applies some of the rental cost towards the purchase.

Advanced Cameras Features:

There are two features that were never part of the original home movie design of Super 8 film cameras that we had to add to better integrate the medium into modern applications. The first is Crystal Sync.

Crystal Sync is a way of synchronizing the pictures shot on a film camera with audio recorded on a separate audio system. Without Crystal Sync "locking" the camera at a precise speed, the frame rate will drift just enough to make it virtually impossible to synchronize even a small portion of film picture with independent audio. With Crystal Sync, you can use many audio devices to achieve sync with a Super 8 camera.

The second enhanced feature is Max 8. Most professional film applications today are widescreen. However, since Super 8 cameras originally designed for shooting home movies produced more or less a square picture, we needed to modify the super 8 camera to work effectively in widescreen.

You could try to imagine the framing in your camera's viewfinder. For years, we used anamorphic lenses to squeeze a wider image onto the Super 8 frame, then "stretched" those images out during the transfer process. For example, director Joel Schumacher and Cinematographer Jan De Bont used this method when shooting the flashback sequences in Super 8 in the feature film *Flatliners*.

Although this does work, it has a lot of drawbacks and is quite cumbersome for the operator. Clearly, it would be more than helpful to actually see a wide Super 8 image, which led to the development of Max 8. Max 8 is our custom modification of your camera's gate and viewfinder systems that allows you to see the image in 16x9 widescreen while shooting, and actually film with a wider image on the Super 8 film.

By modifying Super 8 cameras to include Crystal Sync and Max 8 features, we have made it far easier to seamlessly use the Super 8 medium in any professional production.

The
POWER
of
SUPER 8
FILM

Insider Secrets Every Filmmaker

Should Know

Rise to Power – A Short History of the 8mm Format

A little history lesson never hurt anyone. It is a little comforting to know that what you are about to get involved with has a great history associated with it. Although in many ways we are breaking new ground in Super 8 film's integration with Digital, the reason this works so well is that the technology is based on time-tested ideas that have worked in filmmaking for almost a century.

Super 8 is part of the evolution of 8mm-wide film formats that started in the 1930s when companies began coming up with ways of shooting inexpensively on film using 8mm technology. By making film less expensive to use, more people could enjoy the experience of shooting motion pictures.

The first form of 8mm film was known simply as "8mm" or what is today sometimes called "Regular 8." 8mm was

created by taking a piece of 16mm film and adding a second set of perforations. The film could then be exposed with a much smaller frame size to save on the cost of film and developing. In 8mm, the re-perforated 16mm roll of film is shot twice. The first time through the camera exposed one side of the film, and then the roll was flipped over and exposed down the other side. This procedure created four times the number of images that would have been created with 16mm film. In addition to the frames being smaller, the film was designed to be shot with fewer frames per second (fps) running through the camera. The original standard was 16 frames per second and eventually progressed to 18fps. By comparison, the established speed for professional film is 24fps.

A 25' spool of Regular 8 when shot at 16fps will yield about 4 minutes of motion pictures. The same roll of film, shot as 16mm at 24fps would yield less than 1 minute. This was a tremendous savings and made the process of shooting motion pictures viable for consumers.

Many of the household names we associate with the film industry began their journey by making Regular 8 movies. Pillars of the film community like Steven Spielberg and George Lucas, began by making their own low-budget 8mm films.

In 1965, Kodak introduced a new and improved type of 8mm film called "Super 8." Super 8 offered consumers a lot of advantages. The sprockets were smaller, making

the image size larger. It was sold in a light-tight cartridge so you did not have to worry about fogging or flipping the film.

Although Super 8 is 8mm wide, it was not compatible in any way with 8mm. You needed a new camera to shoot it and a new projector to screen it. As Super 8 became popular, new variations emerged. These required custom cameras or cartridges to expose the film but resulted nonetheless in a standardized Super 8 film for projection.

Double Super 8, for example, is a cross between 8mm and Super 8 where the film is sold on a roll and shot down each side like 8mm. When it is processed, it is slit and becomes Super 8 film. Single 8 is Super 8 film loaded into a cartridge designed by Fuji. You have to have a Fuji Single 8 camera to go with Single 8 film but when it is processed, it then becomes Super 8 film. There was even an instantly processed Super 8 film called "Polavision." This Super 8 film came in a Polavision cartridge and used chemicals in that cartridge to instantly develop the film after shooting. Although this film was designed to stay in the cartridge for projection on Polaroid's custom projector, you can bust these open and retrieve the Super 8 film.

In 1992, I introduced a new form of Super 8 film called "Pro8." I did not want to call my film Super 8 because that way when filmmakers purchased it, they would know something was different with this kind of Super 8 film.

Pro8 is essentially a negative film version of Super 8 film. All Super 8 film before Pro8 was reversal film, meaning it was processed as a positive image. It could be shown by simply projecting light through the material to see the images, similar to the way you would view a 35mm slide.

In 1991, I was living through my first major recession, one that was very similar to the one we are going through right now. One moment we were humming away selling Full Coat sound recorders, making music videos, using Super 8 in commercials...and then, boom! Everything ground to an incredible stop. In one month, our sales dropped in half. It took a while for us to accept that the world we were living in had now changed and we needed to reinvent ourselves.

At the time, big companies like Kodak were cutting non-profitable products and services. We got a letter announcing that they were soon going to discontinue Ektachrome Super 8 film. Since Super 8 now sold a fraction of the volume it had when it was used for home movies, the format was definitely on the list of things they might cut to save money.

For years, customers had asked for more choices in film stocks and I would beg Kodak, but nothing ever happened. Since there was not much else going on, we began to explore the possibility of making our own super 8 film. This would require three things to happen: First, we would have to take the machines we used for making

Super 8 Full Coat magnetic tape – more on that later – and convert them to making film. In addition, we would now have to do this process in the dark.

Second, we needed Super 8 cartridges to load the film. I knew a customer from the former Soviet Union who was going to school at Massachusetts College of Art in Boston who had come into the office. He had wanted us to process this black & white film he had from Russia that came in a *reloadable* Super 8 cartridge. If we could get our hands on some of these cartridges, we could load our film in them. Today we have an arrangement with Kodak to use their single use cartridge.

Finally, we would have to process the film. We had an Ektachrome processing machine that would become obsolete when Ektachrome was discontinued, so we could convert this machine to process color negative.

It all began to sound possible. We found the student from the art center who was going home for the summer and gave him some cash to try to buy the reloadable Super 8 cartridges. He was able to acquire 2,000 of these that he stored in his grandmother's garage. Each time he made a trip home for a holiday, he came back with a suitcase full of these Super 8 cartridges.

We set up a dark room where we put the 35mm film perforator and slitter that we had been using to make Full Coat, but the processing was causing the most trouble. The chemistry used to process color negative differs

enough from that used for Ektachrome so that even though the processing machine worked, the chemicals were corrosive to the structure of the tanks inside the machine. This made the machine break down a lot.

Negative film must be transferred to something to produce a positive image that you can watch. Most professional motion pictures are shot on negative film and then scanned either to digital or printed for showing. At this time, there is no real application for printed Super 8 film, so it is scanned to digital for display. Unlike the evolution from 8mm to Super 8, there are no compatibility problems between traditional Super 8 film and Pro8. Pro8 film can be shot in the same cameras as Super 8.

Why Pro8? Well, Pro8 film was created so that Super 8 filmmakers could use the same modern film stocks typically used by other professional filmmakers. Pro8 combines the consumer aspects of Super 8 film with the professional aspects of filmmaking.

Hundreds of thousands of filmmakers have shot Pro8mm since its introduction. Super 8 negative is the most popular type of Super 8 film with professional users. Because it is so popular, Kodak decided to introduce their own color negative Super 8 film. You know you have the power when companies the size and might of Kodak copy you.

In 2005, I introduced Max8mm. Max 8 uses film in the same cartridge as Super 8 and Pro8 but the camera is modified to expose a larger, more rectangular image on

the film. Max 8 also needs to be scanned using a device that is modified to show the Max8mm frame. We created Max 8 to give Super 8 users the ability to work in widescreen. Since most modern film applications like HD and 35mm film use widescreen, Max 8 is rapidly becoming the way to do Super 8.

There are two ways to achieve Max 8. The first is very inexpensive. You simply expand the camera gate on any Super 8 camera. The second method is to have your camera fully modified for Max8mm so that the optics are re-centered and you add a viewfinder that allows you to see the actual widescreen frame. Either way, I believe one day Max8mm will become the standard way of using 8mm.

Although with some investigation you can still find limited support for most of the 8mm film forms, Super 8 and the use of Pro8 film are by far the most popular and easiest-to-access production methods. There are millions of Super 8 cameras in the used market left over from the days when consumers used Super 8 as a home movie format.

Max8mm is a relatively new form, but it is quickly gaining in popularity. For example, John Mellencamp had his summer 2009 concert shot in Max 8 using Pro8 film. The Super 8 sequences in the 2009 feature film *My Sister's Keeper* were shot in Max 8 using Pro8 film. All of the Beck videos that used Super 8 were done in Max 8, some using Pro8 film and others using black & white.

The
POWER
of
SUPER 8
FILM

Insider Secrets Every Filmmaker
Should Know

Power Supply - Film Stock & Processing Options

One aspect of film that is fundamentally different from digital is the film stock. Each film stock has its own characteristic based on how that stock is designed by its manufacturers. These stocks give you different types of image canvases with which you can create.

The power in digital comes from the ability to manipulate your image with computers and software. The power of film is in the film stocks that continually evolve. If you *shoot* on film and *edit* in digital, you get the benefits of both. Because the film is independent from the camera, you change it easily and improve the image. In this way, you can vary the "look"of a project by simply switching rolls of film.

Film also evolves based on the stock. The film we shoot today is nothing like the film we shot five years ago,

which was not like the film five years before that, etc. We are talking about 100 years of evolution, new and exciting varieties of film that are still shot in the same type of camera that has been around for that 100 years. Because of this, shooting with film is never out-of-date or "Old School."

One tremendous asset of film is that you can take advantage of these improvements by simply purchasing the new stock. You do not have to change your camera every few years to be part of this forward progression. All you have to do is load your camera with a new stock and you are ready for a world of change in image creation. Innovative film stocks keep film new and fresh because as stocks change, so do the looks of the projects created on film. Unlike with video or digital, where you have to completely change your equipment to be part of the future, all you have to do in film is change the material you're shooting with and you can create a completely different world.

For most of its history, there were only a few stocks offered in Super 8. This was because Kodak mostly controlled Super 8 film at that time, and they did not see the potential for the professional use of Super 8. In 1992, I introduced the first new Super 8 film stock in many years, Pro8mm color negative. Today there are over 25 film stocks to choose from, made by different manufacturers and using three different types of film materials, each offering different ways of handling this

material to give the filmmaker even more options.

I recently worked on a feature film called *Days of Grace* and I think these filmmakers are going for the all-time film diversity record. They have shot in Super 8 Kodachrome, VNF Ektachrome processed in E-6 chemistry, Super 8-85 E-6 processed Normal and the same stock Cross Processed, E-6 85 loaded into a Fuji Cartridge processed Normal, Fuji Ektachrome processed as Fuji shot single 8, Fuji Ektachrome Cross Processed, dozens of different Color Negative films from both Kodak and Pro8mm, and, of course, Black & White reversal. Every time they sent in film for processing and transferring, it was a new combination.

Super 8 film stock falls into three categories based on the three different types of materials from which they are manufactured: Color Negative, Color E-6 Ektachrome and Black & White. Each film material requires a unique chemical film process for developing.

The largest group is the Color Negative films. Color Negative film is by far the most widely used professional film material. The two major film coaters, (Kodak & Fuji), offer a wide variety of ASA stocks with different color balance and characteristics. Although Kodak offers only two of its Color Negative stocks as Super 8 film, filmmakers can purchase other emulsions from Pro8mm, as Pro8mm makes Super 8 film versions of all Kodak and Fuji 35mm motion picture stock offerings.

Kodak codes its film with a prefix for the gauge and then a two digit stock number. For example, 5201 is 35mm film, (52 is Kodak's prefix for 35mm film), with an ASA of 50, (01 is their stock number for their 50 ASA daylight Vision 2 film.)

Pro8mm uses the same coding, so you know that Pro8-01 is Kodak's 35mm 01 stock, perfed, slit and loaded into Super 8 cartridges. Fuji uses a similar numbering system so you can easily match up its 35mm and Super 8 film versions.

Using the Super 8 version of these stocks is exactly the same as using the large format version. This was a crucial improvement for the professional use of Super 8 films since it meant that professional filmmakers already familiar with the characteristics of various film stocks could translate their experience when using those stocks in Super 8.

Conversely, filmmakers who are learning about film using Super 8 are using the same film types they will be using in professional applications, making this transition and the learning about stocks equally applicable.

Most film is balanced to create the best color reproduction under either Daylight or Tungsten light. Many films have two versions, one for daylight like 01 and the same film balanced for Tungsten, like the 12.

Both Kodak and Fuji are continually improving the

quality of their film stocks. Kodak is currently supporting a line of Vision 2 film stocks that it is slowly replacing with Vision 3. Both their 07, a 250 ASA Daylight, and 19, a 500 ASA Tungsten, are available and Kodak is promising more to come.

Fuji still has its Super F series of film and its Eterna and is now into their Vivid line with their 43, a 160 ASA Tungsten, and now 47, a 500 ASA Tungsten stock.

There are also a few specialty stocks, such as Kodak's 99 and Fuji's 92. These films are designed not to need color balancing.

The availability of these new stocks in Super 8 makes it very convenient and cost effective to test and explore these new materials.

Kodak's most current trend is to create film that has such enormous latitude, that every area from light to dark is exposed. This makes the work of exposing film much easier to accomplish using significantly less lights. The underlying idea is to let the film do the work required to get an image, and then tweak the look for the project in transfer or postproduction. This is fantastic for new-to-film filmmakers because it makes doing basic motion picture photography much easier to achieve.

Although Fuji was also offering these extreme latitude stocks with their Eterna line, they have designed films in their new Vivid line a little differently to create more of the look with the film.

The second group of Super 8 film stocks is the E-6 Ektachromes. There are currently two stocks in this group, Kodak's 64T and Pro8mm's Super 8-85. E-6 Ektachrome is very different from the previous VNF Ektachrome film stocks of the past. In fact, this modern Ektachrome has characteristics that make it much closer to the now-discontinued Kodachrome film stocks. Like Kodachrome and the old Ektachrome, E-6 Ektachrome is a reversal film that results in a positive image when developed so you can use this film for direct projection or editing directly with the film. It can also be developed as a negative in a technique called Cross Processing.

Black & White films comprise the last group. There are presently two stocks in this group. The first is Tri-X, made from Kodak 66 stock, a beautiful general-purpose reversal B&W material. The other is Pro8mm Super8-63. This is a highly specialized material we call "Hi–Con" with an ASA of 10 and practically no exposure latitude. Although difficult to work with, the results are very striking with virtually no grain. These are also processed as positives so that they can be directly projected or edited on the film.

When choosing a film stock, you have to weigh the criteria of the stocks verses the production situation, balanced with the look you are hoping to achieve and a few other factors. In general, negative stocks are easier to expose correctly and come in a larger variety of ASA and color balances. Reversal stocks are more difficult to

expose correctly and are limited in ASA and color balance options.

Low ASA films need a lot of light to expose correctly. Higher ASA stocks can be exposed with less light, although the high ASA can easily be brought down with neutral density filters, allowing the film to be used with a lot of light. I recently exposed some of the new Fuji 47, a 500T stock, using only an 85 filter in full California sunlight with no problem.

The advantage to using lower ASA film is the tighter grain structure in the image. The disadvantage is in the lack of production flexibility with low light.

One thing about film stocks is that they are all a little different. They are made of different materials, have different thicknesses, different backings, and so on. Although they are all designed to run through the average Super 8 camera, they may not do so with the same results.

Although negative film is much easier to expose correctly and is much more flexible, it is more difficult and costly to handle correctly and scan to digital. Reversal films can be scanned to digital using less expensive technology while still achieving satisfactory results and are much easier to keep clean in handling. Black & White film is the most prone to get scratched while negative film the least likely. 99.9% of all professional production is done with negative film.

Black & White is the tiniest, most flexible and easiest to transport. Although this sounds like a good thing, it can be problematic if the camera's take-up does not slip correctly or if the gate is worn down.

Interestingly, we used to sell a camera based on a Russian spring drive take-up called the Kinoflex. We often had problems with this camera when using Black & White film because of the inconsistencies of the spring take-up.

We never had problems with this camera when shooting color negative Super 8 films. In fact, it worked so reliably that we have used this inexpensive camera and Super 8 color negative film and received fabulous results on TV shows for Disney, commercials for Burger King and Music Videos. But because of the potential for these and other problems, and to allow you to gain understanding of a particular stock, you should always shoot a "Tester" before you start a project.

A tester is usually a single roll of film that you pay for, along with the processing and scanning. This is the best way to not only check out a film stock, but also prove that the stock works best throughout your entire workflow before beginning a project.

You can start by logging onto the web at Pro8mm.com to get some basic ideas about how a stock will look. This is just a beginning point, as every film will look different depending on how it was exposed and who exposed it. You have to combine the skill of the filmmaker with the stock

and equipment for the film to obtain its full potential.

Since I shot most of these demos, you can see that even a former accountant shooting with the kids in the back yard or on vacation can, with a little practice, get great images with Super 8 film. To master shooting on film, you need to acquire the intangible skill of the artist we call "filmmaker."

Before you can transfer an exposed roll of film to digital, it must be processed. Processing means running the film through chemistry to bring about the exposed image on the film. Each of the three types of Super 8 film must be processed in its own unique chemistry. Push processing means leaving the film in the developer longer to shift the low-level exposures up into the mid range. Pull processing, shortening the amount of time the film spends in the developer, does the opposite, bringing the high levels found in over-exposed film down into the mid range. Either process can be done for different durations so that you can achieve different levels of Push or Pull. For example, "Push 1" is an attempt to push the film 1 stop.

Push and Pull processing is no long as useful a tool as it once was. When film was only projected, you needed techniques like pushing the film to save underexposed film materials. Today, since most film is scanned, pushing or pulling the film in the lab is redundant, if not useless. A good scanner can push more light through the film and can extract any image that exists on the film material. In

addition, since you can see the image during this process, you can determine exactly how much to push or pull the film without guessing. It is simply more cost effective and easier to manipulate the film's exposure levels with the scanner.

For years, I have been explaining how pushing and pulling film is a waste of filmmakers' money with very little success. I'm not sure if this is a result of inertia, i.e. just too many years of doing film a certain way, or if it comes from a lack of true understanding of the process, or if it's just a case of filmmakers hoping that if they exposed the film incorrectly, it can be fixed at the Lab.

Push processing cannot create any image if it is not already on the film, and since the scanner can extract any existing image anyway, pushing or pulling film at the lab before scanning is just a waste of money. However, after years of arguing over this with customers, I have resigned myself to letting filmmakers do what they want.

Cross Processing is a special technique whereby a lab processes Ektachrome reversal film in color negative chemistry, in essence deliberately processing the film incorrectly to turn the film into a negative image. This is actually a very interesting technique that produces a very pleasant image because it offers the contrast found in reversal film with a sort of edginess you need to see to understand.

If you want to experience the best accountability possible

from your Super 8 processing & scanning experience, you should have your film scanned directly after processing at the facility where it was processed.

You achieve big advantages by combining these essential services. If you separate these two steps and wind up with a disappointing end product, it is often impossible to determine which step was at fault. Instead, you will probably get stuck in what I call "The Blame Game."

Since processing labs and scanning companies are often competitors, they will naturally try to win over your business by blaming the problem on the other company.

In addition, scanning can sometimes provide remedies for processing issues. If you are scanning at the lab where you processed your film, they will often offer these extra services at little to no charge if there was the slightest possibility that their lab caused the problem.

However, if your scanner is not at the same facility as your lab, they will charge you extra for fixing these problems, blame the lab, and suggest that you get the lab to reimburse you for the scanning company's fees. (Good luck!) Again, you will be forced into the middle between two aggressive competitors, not a very nice place to be.

Before film can be scanned, it must be prepared for the scanning process. Different machines scan in different ways and require different kinds of prep to maximize the scanning process. When a lab also does their own

scanning, they carefully address every aspect between the lab and their own scanning department.

If your film is prepped at one lab, it may not be optimized for another's scanning process. For this reason, some scanners have you collect your film from the processing lab unprepped. This is a big mistake because the best time for film to be prepped is right off the processing machine. You will notice a marked improvement for films like Super 8 negative if the film is prepped immediately in the lab rather than spooled onto 50' reels first and prepped later.

At Pro8mm, we take many steps to keep Super 8 film clean. We always prep the film right out of processing. For negative Super 8, we use our own custom-made leader that is actually film that has been exposed for this sole purpose. We only scan on Y-Front scanners that use diffused light to mask some of the dirt on the film. Every time we run a roll through any device, we re-clean it. We even have cleaners on the scanners that clean the film as we scan it. All these steps contribute to a clean look of super 8 negative.

Lastly, processing film well is a difficult task that is getting more difficult to do as the pool of qualified people who do this art keeps shrinking. Film cannot exist without lab technicians to process it. If you want to keep film alive, you have to support the labs that actually do the processing. By supporting the places that process film, you are supporting the future of filmmaking.

Chapter 5:

Power House – Scanning 8mm Film to Digital

Transferring film to Digital is actually a very simple task. All you need is a film projector to show the film and a video camera to record the images. You simply project the image on a common surface, point the video camera at the projection, press "Record," and you have done a transfer. If this doesn't seem that complex, it isn't.

Every day I go to work and transfer 4 to 6 hours of Super 8 film to digital. I have been doing this for the better part of the last 17 years. I have been working on Super 8 film-to-video transfer systems for over 25 years. After selling systems for years, I started doing my own transfers because of my desire to go much further than what other companies wanted to offer. I have fine-tuned and invested in the process of handling Super 8 to an incredible degree.

When I first began doing transfers, I rigged up a Super 8 projector to a mirrored screen, pointed a video camera at the projector and did the transfer with about $500 worth

of equipment. I know of two very prominent companies that do transfers, one a big box store and the other found on the Internet, and that is exactly how they still do their transfers.

The machine I use today is a Millennium 2 from Cintel. It cost $600,000. Add to that the Controller, a daVinci 2K Color Corrector, and the various other devices it takes to do all the things I do with Super 8, and my latest system comes in at just under $1 million worth of equipment.

I think the only way to understand why I went from a $500 system to one that cost close to $1 million is to understand my passion for Super 8. Transferring film as I did in the beginning could, in fact, put a Super 8 image on video. If all you want to do is watch the image on a TV from a DVD rather than projecting it, then go on eBay, buy yourself a projector and do your transfer.

But for some people, Super 8 film means a whole lot more. It is the medium on which they recorded some of the most important images of their lives. It is a unique image format with a set of qualities that even today's best high definition digital cannot duplicate. These image qualities have created a market for Super 8 today.

At every step of the way, I have found that improving the quality of Super 8 has opened up new opportunities for the use of Super 8 film. Today it is not that uncommon to see Super 8 used in a major motion picture like the 2009 release *My Sister's Keeper*, a Hi-Definition TV show like

Brothers & Sisters, a commercial for Ralph Lauren, a music video for John Mellencamp, wedding videos, sports productions like NASCAR, documentaries, etc. Without acquiring the ability to take Super 8 images to a level that exceeds filmmakers' expectations, Super 8 would never find its way into the world of these projects.

My perception of the powerful quality Super 8 film could achieve began to change radically in the late 1980s. After the days of my $500 system but before I had obtained our Cintel, I transferred using a customized Sony model BM2100 projector pointed at a 3-tube JVC video camera. This system cost about $5,000 and I charged $125 per hour of Super 8 film to do a transfer.

I had a customer at the time, Rich Work, who was making a documentary about his son, a game warden at the Chobe National Game Reserve in Africa. After he finished editing the film, (using his camera original), we transferred it to video. It cost him about $200 to transfer his 90-minute film to videotape.

I was very proud of the quality we had achieved and I asked Rich if I could show his film at a trade show we were attending at the Javits Center in New York City in a few months.

Rich replied that though he was happy with the quality as well, he wanted me to take the film to one of those over-priced Hollywood post houses and have them transfer it to see if it could be made even better.

I told him how crazy I thought he was since, as I knew they would charge $350 per hour of their time and they estimated it would take 3 to 4 hours to do the work, it would cost him almost 10 times what we charged!

Rich repeated that he was not unhappy with my transfer, but after all the effort he had put into the film, he was willing to take the risk just to see if it could be done better.

When I got the transfer back, I was blown away. These were by far the best images of Super 8 on video I had ever seen. I just could not believe the level of quality Super 8 film could achieve when properly scanned to video.

Rich agreed to let me take a 5-minute sample of the film to New York for the trade show, and I had my best show ever. Filmmakers were stacked up in my booth and just could not believe the images they were watching had been done on Super 8 film. Many thought it was some kind of a trick because not even their films, shot in 16mm or even 35mm, looked this good.

I had a millionaire-turned-filmmaker in the booth next to us who wanted to purchase my company because the image quality of his 35mm film did not compare. I enjoyed the offer but I knew that his 35mm movie had been transferred with one of those projected-on-the-wall systems and I had to come clean with him about what role scanning plays in the end quality.

It was then that I realized the power of quality images.

The quality we achieved with these images was so impressive, I am positive it changed the attitudes of thousands of filmmakers about the potential of using Super 8 film. So rather then settling for being able to do something as straightforward as scanning Super 8 film to digital cheaply, we changed the face of Super 8 filmmaking forever.

Rich Work raised the bar on the potential of Super 8 film. I probably sold several million dollars worth of Super 8 equipment, film, processing, etc. based on his demo. The experience also began my quest to be the one who continued to raise the bar on Super 8 film.

Since I am 100% biased in this area, the best advice I can give you is to try before you buy. A simple Internet search can give you a list of companies that will move Super 8 to digital. Many companies are now offering testing services so you can sample their stuff for a small price before you commit. Do it. Because there is such a diversity of services offered, it is not simply a matter of getting what you paid for, but rather not getting ripped off.

At Pro8mm, we charge different rates based on such factors as the value of the different equipment that we use on a job, whether that job has to be scheduled for a specific time or if the transfer time is flexible, whether it's a one-light transfer or if it involves scene-to-scene correction work, etc.

As for the people who project Super 8 on the wall and transfer it for so many cents per foot, I'm sure they fill a

niche in the world. Personally and professionally, Super 8 film has provided me with too much to see it treated with such little respect.

The Power behind great Super 8 images (The M2 Scan Suite).

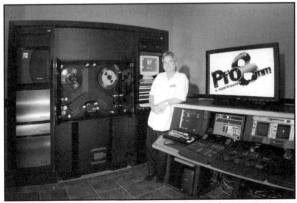

photo by Rei Sutton

The components of the Scan system are:

- The Operator (Colorist)
- The Scanner (M2) with Y-Front Technology
- The Gate
- The Color Corrector
- The Monitor
- Time Logic Controller
- Meta Speed
- Scanner Controls
- Sound Heads
- Output Format

The M2 Scanner is a State of the Art, multi-format scanner. It can scan any gauge of film, from Regular 8 to 70mm, into any digital format, from Standard Definition to 4K resolutions. At Pro8mm, our M2 has been set up to scan from Regular 8, Super 8, Max 8, 16mm and Super16 film to Standard Definition in 525 and 625 (Pal), High Definition 1080i 59.94, 1080i 50, 1080p 23:98, and 1080p 25. We do not have the options for 35mm or 70mm film or 2K & 4K, but we could order these if a project that could justify the purchase presented itself.

The Scanner uses Y-Front technology. This is a special optical system that can masque some of the dirt and scratches on the original film so they are not as visible in the scans. It does so without altering the look of the film or adding artifacts to the image.

The Gate sets up the optics and transport for different film gauges. Because our gate scans the entire image from the sprocket to the very edge of the frame, it can handle 8mm film in all its forms, from Regular 8, Single 8, Super 8, and Max 8. This was a custom modification we had to do to our gates. We also have a 16mm gate that can handle both traditional 16mm and Super16 films.

The Color Corrector is the console controller for the Scanner, but it also has its own abilities to manipulate the color and contrast of an image. Pro8mm's system uses a daVinci 2K Color Corrector, which can handle all the formats we presently support.

Color correction can be achieved in many ways depending on the situation and the budgetary needs of the customer. In its simplest explanation, the Colorist uses the Corrector to adjust the amount of Red, Green and Blue light he or she pushes through the film to manipulate an image. The Corrector can adjust all aspects of an image, from contrast to color saturation to framing.

Typically, at Pro8mm, we scan three different ways: Scene-to-Scene, One-Light, and Supervised. A Scene-to-Scene transfer is one that has dedicated settings for every scene on a roll of film. The Operator programs this information into the daVinci, which can accurately perform the corrections with frame accuracy on the film.

A One-Light transfer is one where we establish a good overall setting for a given reel of film. Then we transfer the complete reel using this setting with minor adjustments made as the film is recorded.

A Supervised Transfer is one where you, the filmmaker, are present to make suggestions about the transfer.

The Color Corrector also controls the framing of the image into various forms. Any film image can be put into any digital framing. For example, you can take the 4 x 3 Super 8 image and frame it up to be a 16 x 9 digital frame.

The Operator of this equipment is usually called a "Colorist," but given that he or she must deal with all the nuances of small gauge materials as much as with color,

he or she is really more of an engineer. Our operators at Pro8mm have over 10 years of experience handling film, which provides efficiency to the work along with good judgment on how to safely handle film material.

The Monitor we use in our M2 suite is a multi-format flat screen. It can display everything from analogue SD like VHS to 1080p HD. Flat screen technology is critical to evaluating modern film applications. The image differences between flat screen and tube technology are critical when it comes to modern color correction. Flat screen tonality and contrast characteristics are more similar between computer displays and flat screens than between computer screens and tube sets. Flat screens are also native 16x9, which is quickly becoming the standard.

Time Logic Controller is a system for handling editing functions between different mediums. When you want to edit between a Scanner and a Tape deck, you need a system that can translate the roll up speeds of different devices so you can make a perfect field-accurate cut. The TLC can handle up to nine devices simultaneously so that multiple machines can all be used together and locked in sync for various applications.

For example, the TLC can provide an HD Master and a SD Master with matching time code; identical copies in different formats. It can also be used to lock Sound and Picture from various formats.

Meta Speed is a device that translates the frame rate of film to the frame rates of other mediums. In its simplest form, if you want to transfer film shot at 24fps to standard video, which runs at 30fps, the Meta Speed will translate 24 to 30 and still keep the natural speed of the material.

Meta Speed can handle hundreds of combinations, including over 400 different film speeds. Along with being necessary in order to keep natural speed for almost every job, it can also be used creatively to speed up or slow down the motion of any piece of film. Although the Meta Speed capacities are almost limitless, we try to advise customers not to use certain combinations. For example, a film shot at 18fps put on HD at 1080p 23:98 PSF will create certain artifacts and should be avoided.

Meta Speed is also the governing system for the transport of the film. Different parameters can be adjusted so that the scanner can more effectively deal with the stability of an image based on film's natural inconsistencies. As film ages, for instance, it tends to shrink and this changes the physical size of the film. The Meta Speed can be reset to adjust for many of these changes. This is particularly important for small gauge film, as these changes cause a relatively more dramatic change in the film due to its smaller size.

The Scanner Controls use Touch-Screen technology to quickly change the parameters of the scanning process. The scanner can be quickly changed to different scan outputs to allow smooth workflow between formats.

Sound Heads are available for many film formats that have associated sync audio embedded directly on the physical film, such as the Mag Stripe found on Super 8 reversal film. This requires a diversified set of sound pick-up devices to play back these sound sources. For Super 8, you can have sound on either of two tracks. In Regular 8, you can have sound on one track. In 16mm, you can have both optical and magnetic tracks.

Having a sound playback recorded while the film is being scanned is a cost-effective way of preserving the original audio while doing the image transfer.

Output Formats: There are two ideas about what is the best format to use for your project. One school of thought says to use the best format you can afford to preserve the most quality you can afford. The second approach is to record the material directly into the process in which you want to use the image. There are good reasons for both approaches.

For example, say you have some home movies you want to watch on DVD using your home theatre. A One-Light scan directly to DVD is the least expensive way to accomplish this.

But what if you decide you now want to edit this film in a computer-based system before you make your DVD? For this, you would be better served by scanning the film to a media file like DV/ (Codec), do your editing, and then make your DVD from your computer-based system.

What if you want the same material in HD for home projection? Then you could scan directly to Blu-Ray Disc. What if you wanted to edit it first? Then scan it to an HD File like ProRes 422, again, edit it in your computer, then either burn a Blu-Ray disc, compress it to DVD, or simply use your computer to play back the files directly to your home theatre.

What if you were a producer looking to put home movie footage in a 35mm feature film or Broadcast TV show?

And so forth.

Because there are so many options available, it is best to discuss your project with our helpful staff to maximize your result.

Here is the 2010 short list of the Digital Output Formats we support, in order of quality:

HD Formats

- HDCAM
- 10Bit Uncompressed HD Files
- ProRes Compressed HD Files
- Blu-Ray Highly Compressed HD Files

SD Formats

- Digital Beta
- 10 Bit Uncompressed Files
- ProRes Compressed SD Files
- DVCAM
- Mini-DV
- DV/ (Codec) Compressed SD Files
- MPEG2 Files on DVD

The
POWER
of
SUPER 8
FILM

Insider Secrets Every Filmmaker

Should Know

Chapter 6:

The Power of One – My Super 8 Story

It's only in retrospect that we see how what we do with our lives makes a difference. I surely didn't start out thinking I wanted to make a difference in the film world. In 1975, I was in my second year of accounting college. I needed a part time job in my field so I answered a posting in the placement office for a bookkeeper at a small company called Super 8 Sound.

At the time, they were in healthy growth mode with about 10 employees. Their main product was something called a Full Coat Recorder, a machine that recorded sound on an 8mm-wide sprocketed magnetic tape material called Full Coat. This was the first system for recording sound in sync with Super 8 film.

My job description was making basic accounting entries that were done manually on ledger cards. They had just purchased a revolutionary new thing called a "desk computer," which literally *was* the size of a desk, from

Digital Equipment Corporation and they wanted me to help figure out how to do the accounting with it. I was not sure about this because the only computer we had at my school, Bentley College, was a main frame that could only do some basic stuff, surely nothing as complex as accounting!

Although I doubted the accounting would work, I discovered that the computer could do something else that was fantastic, which was the ability to type something into it, make changes and then print out what you had written. This was an amazing revolution, since up to that point, I had to type all my term papers on an IBM Selectric typewriter and if I made a mistake, which I often did, I had to start over. That capability alone made it worth going to work at Super 8 Sound, even though I had to get permission from my professors for them to accept the computer printed papers.

There was always something new and exciting happening at Super 8 Sound. The founder, Bob Doyle, seemed to be everywhere and working with everyone. One time, Kodak came down and made a short documentary on how to work with Super 8 Full Coat. Customers would fly in from foreign countries around the world to this hole-in-the-wall office in Cambridge, Massachusetts to find out about the products. Customers were working on everything imaginable. They had a psychiatrist who wanted to document new patients as they entered the facility, companies that were exploring hair loss, crazy young

filmmakers doing experimental movies and filmmakers making documentaries about practically everything.

Even though my job was in accounting, I became fascinated with the people and players behind the numbers, as I found that to be much more exciting than doing accounting.

Things plodded along and I eventually graduated and went to look for a real job in my field, and I got one at a company called Commercial Information.

Although this was fun for a time, the company never offered the excitement of working with the kind of people who do film. After a couple of years there, I'd had more than my fill of accounting. About that time, I got a call from one of my old Super 8 Sound employee friends. We went out for drinks, one thing led to another, and I was offered a great job back at Super 8 Sound in the management team.

Although some things had changed, like the original owner/president Bob Doyle was no longer there and some of the others were gone as well, it all sounded like I would be returning to the good times.

My first assignment was to go to Germany and help at the International Fotokina Trade Show. After 2 weeks of trying to learn to speak German, I could clearly say in a great German accent, "*Svi Bier Bitter*," (Two beers please), and "*Das is a Ton banger*," (this is Full Coat).

I returned to the office in Cambridge and delved into the management of a small company when I quickly discovered that the fun company of my college days was in terrible financial trouble. I did a quick budget, only to find that they were losing about $20,000 per month on sales of just over double that. I then did the balance sheet and learned they were about $300,000 in debt. It didn't take long to realize the company's impossible financial situation. What just a few weeks ago had seemed like the opportunity of a lifetime was now my nightmare of managing a company that did not have enough money to pay its bills...or pay my salary.

After almost 6 months of this insanity and watching a difficult situation get even worse, we had to do something radical. I talked to one of my old college professors, who told me one-way out would be to file Bankruptcy. I had studied a bit about this but I had no idea how to do it. So I got a referral for an attorney in Boston, set up a meeting, and a few weeks later we filed Chapter 11.

The lawyer charged us about $10,000 for the service. This did not get us out of repaying the huge bank loans that had been taken, but it did keep the creditors at bay and relieved a lot of pressure. We no longer had to dodge the phone, which helped a bit with sales. We still had to come up with enough money for payroll, which was helped by the fact that most of the employees had quit.

The only big challenge was repaying all the bank loans. We struggled along for almost a year, but with most of the key employees gone, sales fell and the situation continued to deteriorate. At one point, I finally decided I had had enough of this stress and I called a meeting with all the interested parties.

We decided to meet at the bank since they were the biggest creditor. There were the bankers and their attorneys, the original owners and their attorneys, and myself. I told them that I was quitting and that I needed to collect the back-salary I had not been paid for the past 6 months. Since the company had no money and since nobody wanted the company, I decided to make a pitch: I told them I would trade my back-salary for the company. My condition was that the bank loan would have to go away, as the original owners of the company had guaranteed it, not me.

After I made my pitch, they asked me to leave the room while they all discussed what to do. I can still remember sitting by myself in the lobby of the bank, half of me hoping they would reject my offer so I could get out of this mess and the other half full of excitement about what I would do with my own company at 24 years-old.

It didn't take long for them to call me in and, as I sat down, they gave me the news that I had just purchased a company. Although I no longer had to pay back the bank

and I owned the company, there was not much of a company left by that point. Our sales were almost non-existent. (I think we did under $5,000 in sales my first month in business). Most of our best accounts, which were film school programs, had begun moving into video editing and no longer purchased our Full Coat machines and editing benches. Everyone I knew thought I was crazy because it was common knowledge that videotape would soon replace film.

But there is something magical about something being yours and the excitement that you feel when someone wants what you have to offer. Filmmakers are some of the most interesting people on the planet. The fact that the public thought video would soon replace film did not sway them from what they thought was the right way to make their films. This is still true today.

The next Monday morning I went to work and the phone rang. There was a person who wanted to use Super 8 film in a project and they needed help with finding the right camera, film stock, and method of post-production. I said to myself then that I would stick with this until the phone stopped ringing.

That was 30 years ago.

Power Surge – Phil's 8 Tips for Better Super 8 Filmmaking

A s part of my job as senior colorist at Pro8mm, I get to scan about a million feet of Super 8 film each year. In doing so, I get to see what's happening in Super 8 from a unique vantage point. I approach my work from two perspectives, one as a creative Colorist trying to get the most out of a customer's Super 8 for them, and secondly as an inspector looking for bugs in the overall Super 8 process. When I spot something that needs improvement in Super 8, I try my best to follow through to make positive changes.

Internally at Pro8mm, I can just go talk to the people most responsible and try to attack the issue. Externally, it becomes much more complicated, as there are competitive concerns to address and some companies just don't see issues the way I do. In addition, there are factors totally beyond my control that can play a major role in the quality of Super 8. These factors are up to the filmmaker.

Each year the technology for scanning seems to improve and I can "fix" the image more. HD scanning now provides me with tremendous processing power to do many things that were impossible just a year ago, and there are new things on the horizon as well. But there are also a few issues that you, the filmmaker, must be aware of, and if you do not get these right, there is very little that I can do to remedy the problem.

As the years progress, the problems seem to change and evolve with each new generation. Those of us who grew up with film as the main picture-taking medium learned some things at every juncture of the photographic process. Learning skills like achieving proper focus was such common knowledge for our generation that we often forget that this is still knowledge that you have to learn.

So here is my short list, as of 2010, of the eight most common areas of concern I see every day in transferring film. I hope that a few quick tips and explanations can help you create better images with your Super 8 camera.

#1) Hair in the Gate

Because of the nature of film and the way it travels through a camera exposing each frame individually, dirt, dust and debris will gradually build up in the camera's gate, blocking light from reaching some of the image. The metal gate frames the film with what should be a smooth

black border. Because you are running film over metal, the film tends to leave tiny deposits on the gate as it passes over it. This emulsion residue is a gummy substance that is barely visible to the naked eye. If this stuff is not cleaned from your camera from time to time, it can cause several problems.

First, the gummy glue can trap foreign substances like hair, lint, and dust and hold it firmly, often in front of the camera's aperture. This results in ugly black globs that usually start collecting around the border of the frame, blocking some of your image on the edges when it does, but sometimes growing big enough to block a lot of the picture.

Depending on the size of these foreign obstacles, a hair in the gate can ruin a shot. In addition, the emulsion build-up can get so bad that your camera can physically scratch the film.

The fix for these problems is very simple. Go to the store and purchase a children's toothbrush, then use it to gently brush a few strokes in the gate between every cartridge. It's amazingly simple but incredibly effective.

Don't use compressed air as all that will do is blow the dirt around and it might blow it somewhere where you can't get it out. In addition, compressed air often does not have the force to move the object because it is stuck in place, not just sitting there, remember? Finally, don't use a Q-tip, as your chance of leaving a fiber of cotton behind is greater than the good you will do when attempting to do the cleaning.

If your camera has never been cleaned, you might need to do some more extensive work. Once it is clean, the brush trick is all that you should need to keep your camera hair-free.

#2) The 85 Filter Situation

In the beginning, all Super 8 film was Tungsten Balanced, which means that the film will produce true colors only under Tungsten light. If you wanted to get correct colors in daylight, you had to use an orange filter called an "85," (sometimes called 85A).

For convenience, every Super 8 camera was built with an internal 85 filter. Usually, the default setting was for this filter to be in place because most filming was done outside in the daylight. There was a clever way to take out the filter when you were filming indoors in Tungsten light. In that case, the filter removal system could be activated by the Super 8 cartridge's notch system, by flipping a switch on the camera, by sticking something into a slot in the camera to take it out, or by some combination of the above. There were a lot of Super 8 cameras and each seemed to have their own idea on how this should be done.

Today, you have dozens of Super 8 film stocks that can be either Daylight or Tungsten color balanced. When you film in daylight with Daylight Film, you do not want to use an 85 filter. At Pro8mm, we have been taking the

internal filters out of Super 8 cameras now for many years. When this is done correctly, it can greatly improve the optical performance of a camera.

Because you can now buy Daylight Balanced Film, it is no longer even convenient to have the internal 85. Some film manufacturing companies prescribe to the cartridge notch for 85-filter removal and some do not. The conventions for doing this 85 thing are a mess so it is up to you, the filmmaker, to understand what your camera is doing and the film you are using to get this correct.

Although you can do some amazing color correction in post, if you don't get the 85 filter right to start with, you will never achieve the brilliance in color your images can have. In addition, all this correcting takes time, which costs money.

#3) Correct Exposure

Setting the correct exposure is one of the most critical aspects of getting the best-looking Super 8 pictures. There are books written on this subject where you can learn the nuances of lighting and exposure reading. The fundamental issue for Super 8 filmmakers today is that too many filmmakers rely on their aging Super 8 camera's internal exposure system to make this critical setting accurately.

Some of these systems were not even that good when they were new, let alone 30 to 40 years down the road! Photography is, after all, painting with light so you have to learn about light, how it relates to different film stocks and how to make the best exposure setting.

My Super 8 images improved dramatically when I bought an inexpensive light meter for about $75 and started taking some readings and doing some experimentation. I found that even the factory settings prescribed by both the film and the camera's manufacturers were not always optimum to making the best-looking Super 8 pictures.

There are so many factors that affect your exposure. Did you know that your best exposure would be different based on whether your Zoom is set wide or in telephoto? For your camera's internal exposure system to work, it has to recognize the notch system in the Super 8 cartridge and be calibrated to it for it to work well.

The ASA notches were designed to cover a wide range of ASA original films from 10 to 640 ASA, measured in 2/3-stop increments. Some Super 8 cameras can only recognize a single setting where others can read all six. None of this means much if the system has not been calibrated in 15 years. Once you own a light meter, it's possible to do some comparisons, if only to understand how your system is working. I use my camera's internal system all the time but I always have my light meter nearby to check and compare settings.

#4) Focus

For those of us who grew up learning basic photography, focusing a lens was such a standard procedure that it is difficult to understand that many filmmakers today do not know how to focus or even need to know how. Shooting good Super 8 depends on learning good manual focus because there are no auto focus systems on Super 8 cameras. Because this is such a necessity, most filmmakers spend some quality time understanding it, practicing it and learning when it is critical and when they can let their guard down.

In the good old days, a lot of photography was restricted to shooting outdoors because of the slow ASA. Today you can find Super 8 with 500 ASA so you can film in some pretty low light. This makes achieving proper focus more difficult, however, because the original design of Super 8 cameras did not take this possibility into consideration.

If you're going to get good Super 8 footage, you need to understand focus and depth of field, (aka "Depth of Focus"), and practice.

To focus a camera with your eye, the system starts with the correct setting of the camera's internal diopter. Everyone's vision is slightly different, so the diopter in a camera calibrates your eye to match what the camera is seeing. There are a lot of methods prescribed to setting

the diopter. I learned using the infinity approach. You set the focus ring of the lens on infinity and then, looking at something far away, you focus the diopter to your eye.

There are also numbers on every Super 8 lens that should correlate to the focus distance between the camera and the subject. These make great reference points to check if you are really getting the correct focus by eye.

Most Super 8 cameras except the Beaulieu uses a range focus system, (aka a "Range Finder"). This is not the easiest system to use, and without the diopter set correctly, there is little chance of getting correct focus. The difficulty for modern Super 8 users is that when you look through a Super 8 camera, you do not see all the information for easy focus. In particular, the F-stop or aperture and the 85 filter comes after the focus optic, so you do not see their effect on focus.

The other way to approach focus is to understand when it is critical and when it's not. When you shoot at full telephoto zoomed in all the way and at full aperture, where the F-Stop is at the smallest number, on a big 10:1 Super 8 zoom lens, the depth of focus is measured in inches. This means that if your focus setting is wrong by even the slightest amount or if you move the camera as little as a few inches, you'll be out of focus.

At the other extreme, if you're at full wide on the zoom and at the smallest aperture, the depth of focus is huge, a window of maybe 50 feet or greater. In this situation, it

doesn't matter where you set the focus because you will be in focus almost no matter what.

Since most Super 8 is shot in available light, you cannot change that. But if you back off a little on that gorgeous lens to a wider setting and use a slightly higher ASA film, you will find focus to be much easier. At a minimum, always make sure to vary your shots so even if you're wrong you have a chance of having some focused material.

#5) Airport X-ray

Since 9-11, nothing has caused more grief to the use of film than airport X-rays. This is a great tragedy for film because with a little knowledge, problems with airport X-ray machines are easily avoidable and the process does not have to be the hassle it has become.

Since that time, I have taken 500 ASA film with me on every trip I have taken, and I have always run my film through the walk-through X-ray without any special consideration.

That's right. I just put the film on the conveyer and let it go through. If they want to rescan it, I tell them to go for it. On one trip, I clocked ten scannings of my film! In all that time, I have never found a single frame with X-ray damage.

What I don't do is ever, EVER put my film in my luggage. That's because the X-ray systems in the walk-through are nowhere near as powerful as the luggage X-ray system. I believe that when the threat level is low, fewer bags get X-rayed and when the threat level is high, more bags are zapped.

Whenever a customer tells me that their film received X-ray damage, I always ask the same question: Did they put their film through the luggage X-ray? Without exception, every filmmaker who's complained about this problem put their film in their luggage. So avoiding X-ray damage is simply a matter of carrying your film on the plane and not putting it in your luggage.

Don't use those X-ray bags or lead line your luggage. All the airport people do is turn up the X-ray system to see inside your bag. You don't have to unpack all your film and hand-check it either. The X-rays don't build up on your film, although your film could receive multiple X-ray hits if you put it in your luggage.

X-ray damage appears as a very distinct stroking of just the blacks in the film. It doesn't matter if the film was exposed when it got hit or not, nor does it matter what the ASA is as I have even seen X-ray damage in PlusX.

The bottom line is if you put your film in your luggage, you will eventually get X-ray damage; if you carry it on the plane, you will not, simple as that.

Because of the danger of X-ray exposure, it is not a good idea to buy Super 8 film from questionable sources. In the film industry, there is a lot of film that is resold because it was not used on a production. This film, commonly called "Recanned" in 16mm and 35mm, can be easily tested and then resold with full integrity when handled by reputable companies.

With Super 8, there is no way to do this type of testing. So if you buy your Super 8 from a short ends reseller, you are taking a big risk because they can't test Super 8 film.

#6) The Mechanics of Film

Super 8 is a technology based strongly on mechanical principles. Understanding a little about how the film travels through the camera will go a long way in helping you get great Super 8 images and avoid a lot of frustration.

One of the important parts of the mechanics of filmmaking with film is simply being aware of when film is running through the camera. Even though Super 8 film comes in a convenient cartridge and is easy to load into the camera, it is still a mechanical process. One common problem that many new-to-film filmmakers must understand is that in a Super 8 camera, the footage counter works off the camera's spinning take-up, not the film actually moving through the camera. So if the take-up is spinning, the counter is

counting. This has nothing to do with whether film is actually moving through your camera.

The take-up spindle is designed with a slip clutch mechanism so that it always spins, regardless of whether it is actually taking up film or not. So what can happen is you think you're shooting because the camera is running, but no film is actually being exposed.

The most common mistake is thinking that the roll of film has not been totally shot and the filmmaker, being unaware, keeps shooting a finished roll of film.

Oftentimes, in the excitement of shooting, you fail to notice the end of roll signal. If you take a cartridge out of your camera and then reinsert it, the footage counter will reset to zero. It does not know you may already have shot some of the film.

Another problem is that sometimes a roll of film will jam or never even get started in the first place. This can be a problem with the cartridge but usually it is with the sensors in the camera. When you first put a roll in a camera, the film must engage the camera's claw mechanism, the sprockets of the film aligning with the camera's claw. Typically this will happen automatically, but if the guides are out of alignment, this might not take place and the roll will never start. It's an easy fix; usually just taking the cartridge out and reinserting it corrects the problem, but if you're not aware the problem exists, you're about to shoot for the next 3 minutes and get no pictures.

The cartridge can also jam. The most common jam problems are caused not by the cartridge, but by the camera. If the clutch of the take-up spindle is weak, it will have trouble keeping pace with the advancing film pulled down by the claw. The film will build up in the take-up chamber and at some point, the camera will no longer be able to support this back up and will quit.

If you take a cartridge that has jammed like this out of the camera and turn the take-up spindle to wind up the excess, you can typically reinsert the cartridge and start filming again.

Many Super 8 cameras use the clutch's spinning to tell them the roll has ended, so if the clutch is weak, the camera will keep shutting down, thinking it has reached the end of the roll.

As you gain experience with Super 8, you will become aware of the sound film makes when going through your camera, and how the camera sounds when running on empty.

The first indicator of any problems you might have is when you pull a finished roll of film from your camera and it's not at the end. With some film stocks, there is an actual "Exposed" stamp at the end of the film, on others the tail of the roll will simply stick out of the cartridge. If, when you take out a cartridge, the film looks exactly like it did when you loaded the camera, you have some investigating to do.

You should always try to run your rolls out to the end. You do this for two reasons: First, that way you know you shot the roll in the first place so you won't get confused on-set, and second, if it does not roll out, you need to investigate the issue.

It is relatively easy to re-shoot something or grab another take to be on the safe side when you're there, in the moment. It's often impossible to return a week later to pick up a shot you're missing.

In addition to the film physically moving through the camera, each film frame has to register in perfect position 18 or 24 times a second to get good stability from the resulting photography. What this means is that a balance must be present between the cartridge, the camera's calibration and the type of film used to make good Super 8 images that have solid stability and registration.

The state of Super 8 is always evolving. Most Super 8 cameras are no longer in tiptop shape and freshly calibrated from the factories they were born in. In addition, most Super 8 technology was originally centered around one stock, (Kodachrome 40), made by one manufacturer (Kodak), and all camera manufacturers set up their new Super 8 cameras to work best with this particular film.

Today you have over 25 different Super 8 films made by several different companies, each film displaying different characteristics when running through a Super 8 camera and cartridge.

And again, Super 8 cameras are aging and change with the aging process. This is not all bad. Remember, it's a balance between the camera, the film stock, and the cartridge that make it work.

For example, many older, less expensive Super 8 cameras have too much take-up torque because the slip clutch system has dried out and no longer slips when it should. If you shoot K40 or traditional Black and White reversal film with these cameras, they will often produce images with very poor registration.

However, if you take that same old camera and load it with color negative film, which is a little thicker film and has a base coating that provides some extra drag, this combination tends to work very well.

My experience is that different cameras just seem to like different film stocks based on the way they have aged. If a camera has a worn-down gate with a clutch that no longer slips and the exposure system is off by 2 stops, you have a choice of fixing it, throwing it away or loading it with a different film stock that provides more drag with greater exposure latitude. It will then work just as well as it did with the traditional film when the camera was new and calibrated to that specific film. Like my Dad would say, "You either raise the bridge or lower the dam."

The best and cheapest way to see if a given type of film is going to work well in a given camera at a given speed is to shoot a test roll. (In case you haven't picked up on it

by now, if you're just starting to shoot film, shooting a test roll is the best place to start to check out a lot of issues).

Don't worry about charts. Just shoot a roll under the same conditions you want to shoot in, and give it your best effort to shoot it in focus and with the right exposure. Once you establish a base, you can expand your testing each and every time you shoot by experimenting with different stocks, speeds and exposures.

Many companies now offer stock, processing, and single roll scanning deals. At Pro8mm, we will even scan it to BluRay HD so you can see how this will all play out in Hi-Definition. This is a costly service to offer, so take advantage of a great deal and way to learn.

#7) Shooting at 18 or 24 Frames per Second.

All Super 8 cameras were designed to film at 18 frames per second (fps). This frame rate was established primarily to save on the cost of film stock. When your camera runs at 18fps, you get a little over 3 minutes of running time from a 50' cartridge. More sophisticated Super 8 cameras also offered the option of filming at 24fps. At 24fps, you will get a little over 2 minutes from a Super 8 cartridge.

There are valid reasons for using either speed, but you have to be aware of the consequences of your choice and what issues that choice will present in post-production.

Because Super 8 cameras were designed to work at 18fps, they tend to work their best at that speed. Film shot at 18fps looks completely professional when properly transferred to interlaced video in Standard or High Definition IE (1080i). Some filmmakers prefer the look of 18fps Super 8 film, others prefer 24fps.

24fps is the established film speed of 16 and 35mm film as well as many High Definition formats. If you go to a movie theater, they are showing the film at 24fps. Because it is the established standard, there are lots of devices and procedures that revolve around images shot at 24fps. In fact, many fundamental devices used every day in the professional film industry will just not work with film shot at 18fps. Simple things like shooting with sync sound are not possible at 18fps. This means that if you originate something at 18fps, you will not be able to use certain tools of the professional film trade.

For example, if you shot something in Super 8 for a feature film at 18fps, you have created a huge mess. There is no easy or clever method that can create 24 frames of film for 24-frame projection from original shot at 18fps. There are ways of doing this, but none that do so without creating artifacts in the image or motion. I have witnessed feature productions in which the

filmmakers loved the look of Super 8 so much they shot hundred of rolls of it for their project...and then dumped every last frame because they did not want to deal with the artifacts and non-conforming problems that come from converting an 18fps original into a 24fps project.

When you send film into a post facility to be scanned to digital, you have to tell the facility at what speed you want the scanning done. There are lots of good reasons to work at 18fps. It has a great look when transferred at the proper speed in interlaced video.

On the other hand, there are strong technical issues to consider when working in 24fps that are critical to getting a good look for theatrical projects and HD projects working in 24fps 24p. All it takes is a little awareness on your part as a filmmaker to make smooth use of the great aesthetics of Super 8 rather than creating a nightmare that makes professional post-production people hate Super 8. It's all up to you.

#8) Your Shooting Framing and Your Showing Framing

Framing has become one of the most debated technical challenges for modern filmmakers because we are in such a great state of change in this area. For years, films shown in a theater were shot in widescreen while film meant for

television was shot in a square frame. We tried to accommodate one or the other whenever a production was done for both. Now TV is moving into widescreen as well and eventually everything will be shot wide...but not yet.

Super 8 was originally designed as a 4 x 3 image size, more or less a square. Modern filmmaking is moving more and more into a 16 x 9 format, or more or less a rectangle. Because Super 8 was designed to be square, there are only minor issues when transferring Super 8 to Standard Definition video, which is also a square format.

However, when you transfer Super 8 to Hi-Definition or for a theatrical format, you have to zoom into the square enough to fill the rectangle. This is a radical difference in the framing. In this situation, you are cutting out a lot of picture, affecting both the resolution of the material and, more importantly, the composition.

When you think of the time you spend with your camera framing up the perfect combination of headroom, an interesting subject matter, etc., it is sometimes devastating to see that composition cropped down to fit into a completely different space. It is a miracle that Super 8 is used in as many wide screen projects as it is when you consider how altered it becomes from the way that it was shot.

There is another option, which is to film in Super 8 wide-screen using Max 8, Super Duper 8, or Anamorphic. All of these formats will fill the Super 8 negative with image

out to the edge of the frame. This will make the master Super 8 frame a rectangle not a square, and make framing for HD much easier while providing better resolution. The difference between using the entire Super 8 negative as opposed to the standard negative when framing for HD is a 20% increased resolution, to say nothing about having the correct framing.

If you are going to use standard Super 8 framing for HD, just keep in mind while filming that you will have to zoom in quite a bit during the transfer. If you frame for this in production, you will be much better off. Again, you must remember to tell the post facility what you are doing. There are so many options that only you as producer can decide what works best.

Power Station - The Super 8 Film Workflow

Workflow is a relatively new term to the moviemaking industry. It describes what formats you will use to achieve your final moving image product. In the past, when your films were shot, edited and shown only on 35mm film, there was no need to describe your workflow. Today, you might be shooting in a variety of originating formats, editing in other formats, then showing in even different formats. Although this has become very confusing to the novice, if you follow certain rules, you'll always make the best choices.

Super 8 film is rarely edited and then shown on Super 8 film, so you need to define how you are going to work with the images. For most applications, you will want to go from Super 8 to digital. You still have to define the type of digital and how you get from film to digital. You will also be making other choices between the best way to archive your film, the best way to edit it, and the best way

to show it. These often involve a variety of different digital formats.

So starting with archiving, the best form to put a Super 8 image in would be as 10 Bit Uncompressed 4:2:2 Data in HD 1920x1080. You can transfer the film this way either to a digital videotape or on a computer as a media file that is usually stored on a Hard Drive. It can also be recorded in either 23:98psf - what many people call 24p for short, but they are actually not progressive images — or 1080i, which is done in 30 Interlaced frames. (There are also PAL Versions, 25psf at 50i. In PAL, you don't have to choose, as they are the same.)

Without going into a lengthy technical discussion, it is important to understand the difference between 23:98psf and 1080i. 1080i is the exact same system of recording we have used forever in Standard Definition digital and video, with the additional resolution found in High Definition. For television, this system works great.

23:98psf is a new standard designed for people who work with film in digital. The reason you have a new system is that it allows you to record digitally with the exact number of frames that are typically used in film: One frame of digital equals one frame of film. This is important because it makes any project that is shooting in film capable of cleanly using digital as an intermediary format that can easily be put back on film. Without this system, it becomes a technician's nightmare to keep track of all the things you must keep track of when you

want to travel from film to digital and back to film again.

As I mentioned earlier, 23:98psf is *not* a progressive format. PSF stands for "Partially Segmented Frames" which essentially are interlaced, but these frames are all complete frames equal to film frames. When film is put into 1080i, which is recorded at 30 frames per second, you have "ghost" frames in the video that are made up of different film frames. This system, sometimes called "3:2 Pull-Down," is how you bridge the fact that your film is shot at 24fps and your video is at 30fps.

If you want the best possible archive of your film, you want it stored frame-for-frame at 23:98psf. Even if you shot your film at 18fps, it is still best to store it digitally frame-for-frame at 24psf, but you will have to slow down this footage when editing if you want to use it at the correct speed.

The quicker way to deal with film shot at 18fps is to record it in 1080i, but this will leave you with many interlaced frames and interlaced frames that are made up of two different film frames are problematic to some processes.

At present, the safest way to store this data is on tape. Tapes will never crash, like hard drives do, they are much quicker for real-time down converting, and they are less expensive. A 2-Hour HDCAM tape holds the equivalent of about 1.2 Terabytes, but costs less than $100. Storing on Hard Drive is more efficient and you don't need a very expensive tape deck to play your data.

Most people do not own an editing system or a playback system that can play 10 Bit HD Data. This is because for every minute of Super 8 film stored at 10 Bit HD, you have 8 Gigabytes of Data; for 1080i, it's 10 Gigs. To push eight Gigs through a device in one minute is too much data for your average computer system to handle. Just to move files this big around is a pain, let alone trying to use them in an application that is as intense as editing. So you have to compress the data to edit with it in most editing systems.

Presently at Pro8mm, we use ProRes; the Mac codec for HD compressed data. ProRes will compress your data by a factor of about five for HQ (High Quality) and eight if you use just standard ProRes. This shrinks your 8 Gigs a minute down to about 1 or 2 Gigs per minute.

These compressed files are usually stored on hard drives. This is not that risky if they were to crash, since they are not the ultimate masters, particularly if you have tape back up.

If it seems like I'm a little paranoid about the Hard Drive crashing thing, it might be because it just happened to me. I was three days into scanning a large job for a famous director and the new Hard Drive I was using just up and quit. I had to re-scan the entire project. I don't know about you, but nothing makes me less happy than having to re-do three days of work because a brand new $300 part failed. This snapped me back to where I was doing tape back-ups of everything that is important.

Lastly, you want to be able to show your work. This is one of the most powerful parts of what is happening in the moving image world today. Finally, we are starting to achieve the download speeds and compressions that make it possible to view quality images on the Internet. This is a two-fold progression, as the Encoders have gotten so much better and the delivery means make it possible.

The Internet is particularly powerful for Super 8 film because as you now know, when you compress the data that makes an image; it increases the quality of its look. When you see Super 8 images properly scanned to High Definition and compressed to standards like Apple TV using the H264 compression for the Internet or on the iPhone for portable playing, you will have a hard time imagining that this is the same Super 8 your parents used to shoot home movies. You will be amazed at how good these images can look.

We all know the Internet is the next great frontier for moving images. But up until quite recently, it has been disappointing for anyone in motion pictures whose work depends on image quality. I remember how excited I was in 2006 when I put my new Pro8mm demo up on YouTube. It took me all of about 2 seconds to realize that at that quality level, no one would understand the power of Super 8 film.

Fast-Forward 3 years and see how far the Internet has come. We are about to witness one of the greatest mergers in our time; that of the moving image with the

Internet. Think of how Google, eBay, and Facebook have changed our lives. Now take all that and add moving images. The Internet is finally big enough and fast enough to support motion pictures.

Over the last 30 years, I have watched how new media has affected Super 8 film. The VCR killed Super 8 for home movie use, but it left us with a system that made images shot on Super 8 and properly transferred to video into a professional medium. I have watched the music industry embrace the professional side of Super 8 with the music video. However, nothing will match the potential of pairing Super 8 filmmaking and the small screen demand of the Internet.

Super 8 film has that look of film that we all find so enjoyable, and because we are watching it on such a small screen, we only need enough image to fill these applications. When you watch a movie in a theater, you need a 35mm image to handle the job. In fact, as the theatrical market continues its growth to IMAX, you will see even more films using 65mm production to achieve the quality needed for this presentation platform.

However, when the screen is only 4" across, you can get the same quality from just a small bit of film. 35mm is 15 times the size of Super 8 film, but the screen on an iPhone or the Internet is 1,000 times smaller than a theatrical screen.

Many of the technical handicaps that we lived with in the past like editing on film, eliminating dirt and scratches,

and even image stability are now routinely managed with digital. When you pair up the aesthetic value offered by using film with the cost efficiency value of using such a small quantity of film material like Super 8, then combine that with inexpensive cameras and modern digital post production, you have what I believe is one of the most powerful image creating toolsets available.

In fact, in many ways, the evolution of film, digital and the Internet are shaping a world where the greatest days for Super 8 might just be ahead of us.

The
POWER
of
SUPER 8
FILM

Insider Secrets Every Filmmaker
Should Know

Final Thoughts:

The Power Connection

Filmmaking is a collaborative process. Just look at the end of any motion picture and you'll notice that the list of individuals and companies involved in the making of a single movie runs into the thousands. And these credits show only the individuals who have a contract specifying that they be named. There are additionally thousands of other people who contributed their talent toward the project who are not listed in the credits.

Before you can collaborate with anyone, you have to connect with them. Connecting requires one of two things to happen; either you have something that someone needs for their project, in which case they seek you out, or the other option is that you are simply there at the right place at the right time, and you can impress upon them that they need you as part of their team to do this thing.

Experience in Super 8 film provides you with the great power of being connected to the filmmaking process. By its nature, just using Super 8 allows you to grasp the

technical issues involved in filmmaking and be able to express yourself with the lingo that makes film work, particularly when you use Super 8 in the same way professional people use 35mm film. Your acuity with the process makes you one with the elite group of people who do the majority of motion picture work.

Let me give you an example. Say you shot some Super 8 and you used the new Fuji Vivid 47 stock in your project. You shoot, you scan to HD, you edit. It really doesn't even matter what you're shooting, even if it's just shooting a friend in your own back yard.

Now you're at a gathering, say a film screening or a festival where you meet a celebrity film person who works in the industry. Because they are in the industry, they know about the new Fuji stock but they can't just grab a $600 roll of this stock and spend another $1,000 to test it out, so they haven't tried it yet. So you start a conversation about your experience with the stock; how you like the blacks in Vivid 47 and how much more punchy the color was compared to when you shot with the older stocks, etc. You are instantly part of the group.

You are connected.

Compare this to what it would be like if you knew nothing about film and were just doing the gaga over the fact that you just brushed elbows with a celebrity and told them how much you loved their work...just like everyone else on the outside looking to get in.

Practically everyone over the age of 30 began their careers in the film industry using 8mm films. The community of people in the film industry that has fond memories of their beginning in this business, whether at school or just making movies with their friends, is a staggering collection of some of the most influential individuals and organizations in the film world. Most of the top filmmakers of our time trace their roots to 8mm beginnings. Because they started in 8mm, when they learn that you are also shooting in 8mm, there is the bond. It's impossible for them to resist taking you in under their wing and telling you stories about their first experiences, about how A led to B and how it was their first Super 8 project that got them connected to the world of film.

Again, compare this to you meeting one of the greats and talking about digital and how film is dead, and you claiming you have no use for learning the craft that is the life blood of these peoples' existence.

I have seen this connectivity through 8mm film happen so many times over my career that I rate the experience up there with love at first sight and other mythical relationships. I was once working on a film for Neil Young called *Year of the Horse* and during a break, director Jim Jarmusch and I were in the front office when Oscar-Winning Actor Forest Whitaker came into the shop to get his Super 8 camera repaired. Jim asked me to introduce him to Forest and the two got straight into their Super 8 experiences. They were both so engrossed in each other's

experiences, they decided to take off and go get some lunch together. Jim didn't return until the next day's session. Their connection through Super 8 created an instant bond leading to their collaboration on the film *Ghost Dog*.

We are all connected in this world through different things, whether it is religion, nationalities, language, etc. For film people, we are connected through our film experiences. Ever notice how you will see a group of famous people who all worked on the same beginning film project? How did all these people come together to make a film like *American Graffiti* and then all go on have enormously successful careers? The only explanation is connectivity.

I have often witnessed the fact that even learning the filmmaking process will be of more value to filmmakers than the beginning projects they create. This was never so clear to me as when I had an actor-filmmaker customer that shot a feature film in Super 8. After transferring the finished film, he tried for over a year to find a distributor, but to no avail. (This was not that surprising as the film was one of the worst films I had ever seen!)

One day he stopped by the office. He was kind of angry, as if it was somehow my fault or Super 8 film's fault that his project was not accepted. He had made a tremendous effort and it had taken him the better part of two years to accomplish it. As things happen, I was talking to another director about the situation and he said he was looking for actors and would give this guy an audition. There were

hundreds of actors going for the part, but because he and the director had an instant connection with their shared experience of enduring the difficulties of making movies in Super 8, our actor-filmmaker client got the role in the feature. He is now a successful actor that I see from time-to-time in popular television programs.

It's also true even on a less dramatic level. As I mentioned earlier, I always bring along my Super 8 camera whenever I travel. I use it to document my family and do tests on the various technical things I have going on at the shop. Everywhere I go, filmmakers stop me to talk about their Super 8 experiences. A Super 8 camera is like a lightning rod for fellow filmmakers.

Like the filmmaking process itself, there is nothing that I have done in Super 8 that I have done by myself. Even some of my proudest accomplishments were really just massive collaborative efforts between many people. One great thing the process of filmmaking has taught me is that great things are most often the sum of these collaborations.

Take, for example, my introduction of Super 8 color negative film. It was filmmakers that wanted it and encouraged me to work out the issues to do it. It was filmmakers using it that made it possible to perfect it. Then there were the dozens of people whose technical skills helped me accomplish it. Even companies like Kodak helped me and provided technical support to make this product a reality.

I take credit for it like a Producer or Director does with a film because it was my house that had to be mortgaged in order to raise the money to get it done and my direction that got it accomplished, but I would also have a credit list as long as that of a major motion picture if I were to credit everyone who contributed to the project.

To be a filmmaker, you have to learn to reach out to the film world, connect and collaborate. If you're a person in China who wants to be a filmmaker, is it insane for you to use film and to send it across the globe to California for processing and scanning? I say, "No." In fact, it is the most powerful thing you could do, because you are reaching out to the film world. You are connecting yourself to over 100 years of motion picture making. If your career progresses, you may, like those who came before you, one day trace your roots to a tiny little 8mm wide film format.

That's the Power of Super 8 Film.

ABOUT PHIL VIGEANT

Phil Vigeant's contributions to the film industry are surpassed only by the talent of the creative cinematographers who have used his Super 8 inventions, techniques and processes to create an enormous body of award-winning work for music, television, cinema and the archival community. His commitment to push the tiny 8mm frame to its maximum potential has been so profound, that only by looking at what his clients have created with it can we begin to appreciate his insight, entrepreneurship and commitment to the power of Super 8 film. Sporting his signature, "If you build it they will come" style of entrepreneurship, he has long been touted by industry leaders as "The Guy Who Saved Super 8 Film." Among his numerous accomplishments, he is best known for inventing Super 8 negative film.

As President and CEO of Pro8mm for nearly 30 years, Phil has led the company, (originally called Super8 Sound ™), from serving primarily university film programs and the independent artist community to its becoming a worldwide resource for cinematographers using it as a professional production medium. His impressive client list includes all the major studios, including Warner Brothers, Paramount,Disney and Nickelodeon; hundreds of shows for MTV and VH-1, including music videos for artists such as Beyonce, Madonna, Jewel, and John Mellencamp; TV shows such as *Dr. Phil*, *90210* and

American Idol; theatrical releases such as *JFK, Factory Girl, For Love of the Game, Armageddon* and *Selena*; commercials for Burger King, Gap, Home Depot and the Los Angeles Dodgers, and home movie archiving of the world's most famous faces, including Elvis Presley, Bette Midler, Francis Ford Coppola and The Eagles.

Phil has participated as a speaker on many stages, including Show Biz Expo, Cine Gear, University Film and Video Association, The Association of Moving Image Archivists, and numerous film festivals and college classrooms. His company has received media attention for its innovations from numerous publications, including American Cinematographer, The Hollywood Reporter and Digital Video. He is a Best of LA Award Winner and Pro8mm was twice named by Movie Maker Magazine as a Top 25 Company in the industry.

Phil and his wife Rhonda, who has run the company with him since its beginning, reside in Southern California where they raised their three daughters.

Workshops and Seminars

Phil Vigeant is available for private coaching, workshops, seminars, lectures, panel discussions and keynote speaking for your organization, industry event, college, film center, or film festival. Phil is the industry Super 8 expert who will inform and entertain no matter what level of experience you have with film.

For more information, or to book Phil for your event, call 818-848-5522 or mail Phil@pro8mm.com.

Super 8 Boot Camps

The Power of Super 8 Film Workshops and Boot camps will give you hands-on experience in the craft of Super 8 filmmaking. At boot camp, you will work hand in hand with Phil as you shoot a roll of film, have it processed and scanned to HD at his Burbank, CA location. Workshops are held at various locations and cover detailed basic Super 8 filmmaking. Pick the session and location that is right for you. Sign up at one of our websites. www.thepowerofsuper8film.com or www.pro8mm.com

PRO8MM Products

For over 35 years, Pro8mm has been innov**8**ing Super 8 filmmaking with their hybrid of specialty film stocks, camera modifications, award winning processing, technical support, and premium scanning. Pro8mm is the #1 choice of the entertainment industry for professional Super 8 work, in both production and archiving.

Visit www.pro8mm.com to see spectacular demos of our work, or shop online for cameras, film and processing, or our popular discount scanning packages.

Call 818-848-5522 and one of the Pro8mm team members will be happy to assist you.

Notes

Notes
